RAYMOND COGNIAT

DEGAS

basic art library
CROWN PUBLISHERS, INC.
NEW YORK

Front Cover Illustration

DANCERS (Detail) 1899
Pastel on Cardboard
Museum of Art, Toledo, U.S.A.

Back Cover Illustration

RACEHORSES IN FRONT OF
GRANDSTAND (Detail) 1869-1872
Oil
Musée du Louvre, Paris

TRANSLATED FROM THE FRENCH BY JOHN GARRETT

DEGAS

The art and life of Degas are particularly expressive of the middle of the 19th century, for this period saw a transformation of society in its tastes, its moral attitude and its essential structure, since economic, political and spiritual power were thenceforth to be in the hands of a class that had never yet had the chance to exercise power so directly, although it had, through its activities in past centuries, been prepared for its role. The leisured bourgeoisie that then took the lead was, in fact, the same class to which the country had in the past owed its prosperity.

This class of society, then, had just become aware of the rights accruing to it, and now that it was officially in possession of the means to act, it aspired to the spiritual and material comfort that norm lly follow from a firmly established position, and felt the desire to consolidate and stabilize a lasting influence. Its ideas, which it believed to be liberal, sought tl eir justification in a kind of permanent logic and tended towards the academic. Unfortunately for this class, however, this same age, this same society, in praising the ideals of liberty, became involved in a course of events that was inevitably to end in revolutions.

Thus we witness a dual trend, made up of contradictory elements: on the one hand, a need for order and a feeling of security, and, on the other, a no less insistent desire for renewal. Thus, the achievements of Degas, as well as his life, may seem to us to offer a perfect solution of the resulting dilemma, for he succeeds in reconciling the most conscious traditionalism with the most original invention.

Edgar Degas, born in Paris in 1834, thus belonged to the good, solid middle class of the period. His father, who was a banker, placed no obstacle in the way of his son's becoming an artist, and it was without any attendant circumstance of domestic tragedy that Edgar entered the Ecole des Beaux-Arts to join a class taught by Lamothe, a pupil of Ingres. Even before this, Degas had shown great

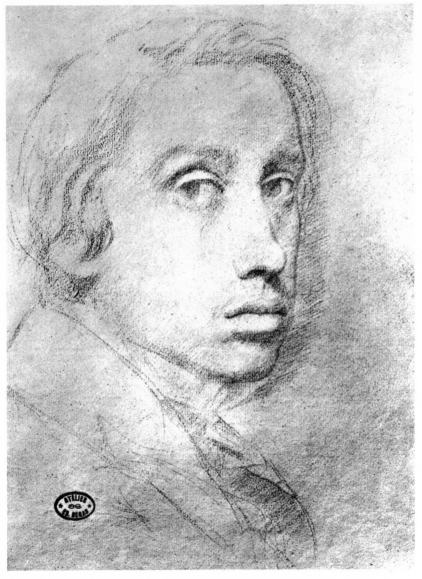

SELF-PORTRAIT
OF THE ARTIST
Pencil drawing,
Private
Collection,
Paris

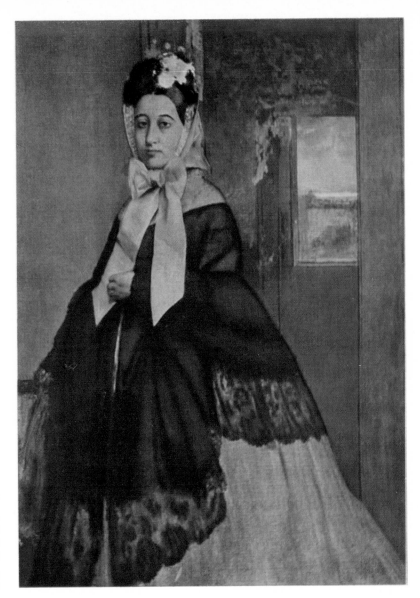

PORTRAIT OF
THÉRÈSE DEGAS,
DUCHESS
MORBILLI
Oil 1863
Musée du Louvre,
Paris

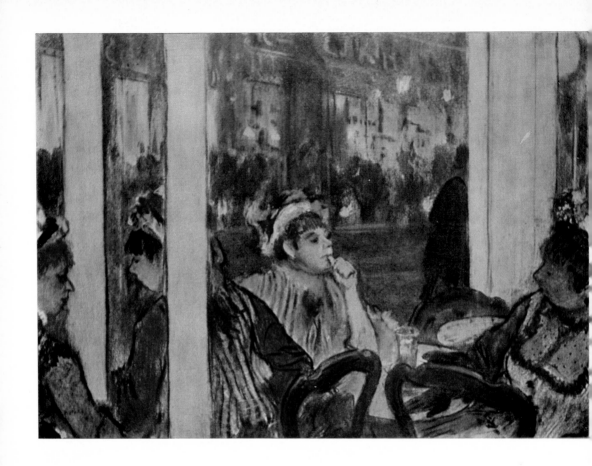

WOMEN ON CAFÉ TERRACE
Pastel on monotype 1877
Musée du Louvre, Paris

RACEHORSES AT LONGCHAMP, Oil 1873-1875
Museum of Fine Arts, Boston, Mass.

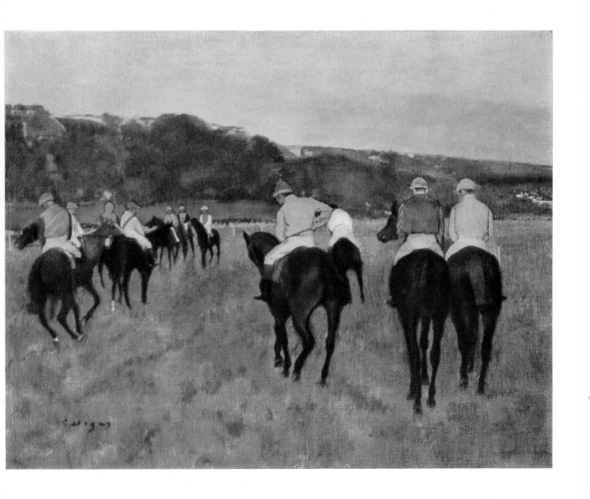

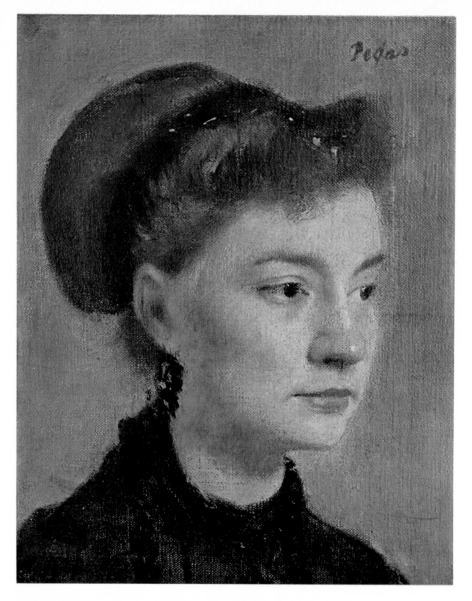

ROSE ADELAIDE
DEGAS
Oil 1867
Musée
du Louvre,
Paris

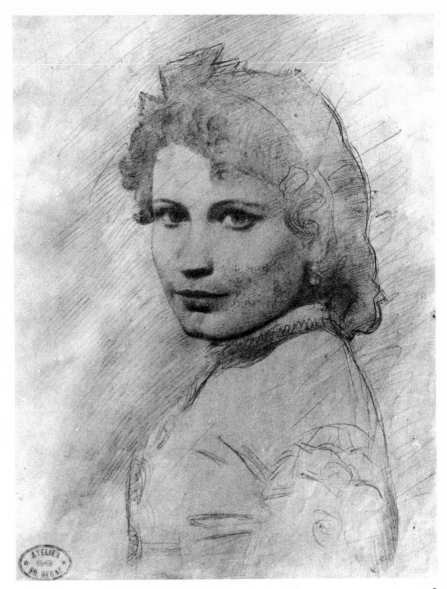

WOMAN'S HEAD
Pencil drawing,
Wildenstein
& Co.,
New York

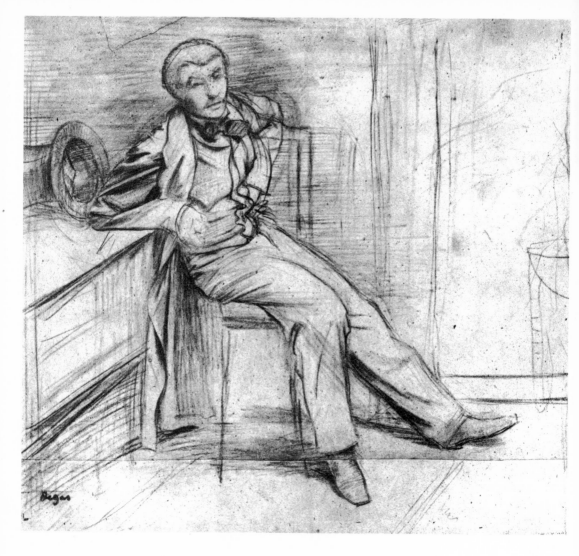

PORTRAIT OF JULES FINOT, Pencil drawing,
Fogg Art Museum, Harvard University, Cambridge, Mass., U.S.A.

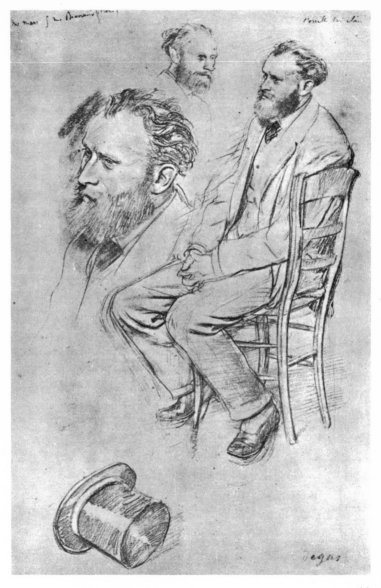

admiration for Ingres, and we are told that, as an adolescent, he frequently contemplated drawings by the master that decorated the drawing-room of a friend of the family's, Madame Valpinçon.

He attended these lectures for several years, although he derived more profit and learnt more from visiting museums. At that time, his admiration ranged from Lawrence to Holbein, via Ghirlandaio. The spell cast over him by the painters of the Italian « quattrocento » was reinforced by the journeys he made at that juncture (1856) to Italy, as well as by other, longer visits in 1858 and 1859, Naples, Rome and Florence continued the revelation of Ingres by showing him the austere and vivid reality of drawing and the unity and variety that form the permanence of tradition. When he returned to Paris, he exhibited his work, but had no intention of adopting revolutionary attitudes. However, very soon, he found himself involved in the first demonstrations for independence staged by young artists. We come across him at the famous meetings at the Café Guerbois in the Boulevard de Clichy, where both painters and writers bubble with new ideas.

Already, despite his submission to the classical disciplines, one can feel that he had, at that time, a technical mastery and acute perception of reality that bespeak a strong personality, limited, however, by certain inhibitions. The copies that he had made formerly of the pictures of great masters might be considered remarkable, but were nevertheless the work of a respectful pupil. Most of his original works remain profoundly influenced by his school training or by his recollections of museums, and there is no real animation in his larger historical compositions, where his classical intentions are evident. However, this attitude of his does nothing to confuse his mind, nor does he ever deny it, since, at a later date, we find him writing: « In order to learn the job of a painter, one must copy the masters over and over again, and it is not until one has given all the necessary proof of being a good copyist that one may reasonably expect to be allowed to draw a radish from nature ».

In his historical pictures there is indisputable merit of a technical or aesthetic order, but the intention to create something new is still contained and, above all, dominated by a conspicuous lack of warmth. One feels that the artist has remained

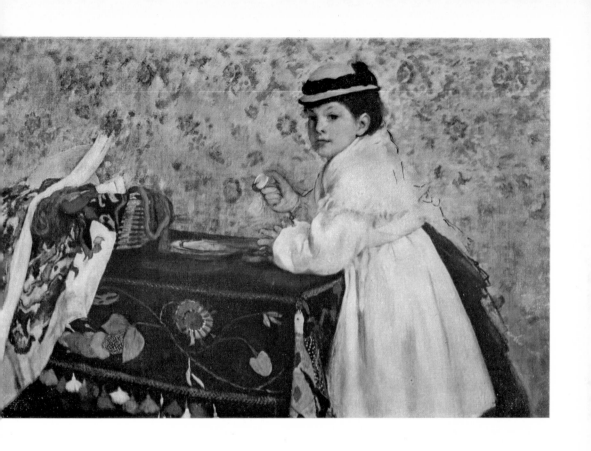

HORTENSE VALPINÇON AS A CHILD, Oil 1869
National Gallery, London

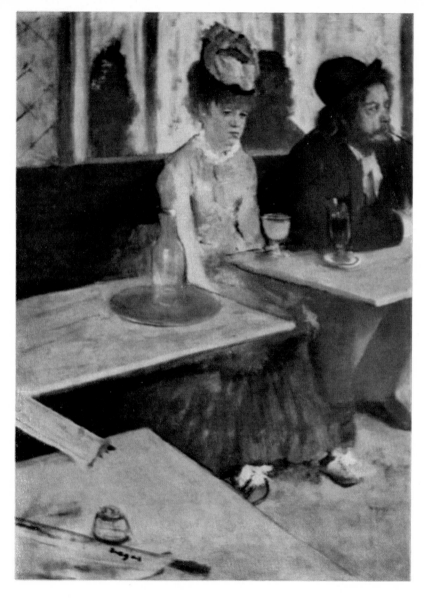

ABSINTHE
DOUBLE PORTRAIT :
ELLEN ANDRÉE
AND MARCELLIN
DESBOUTIN
Oil 1876
Musée du Louvre,
Paris

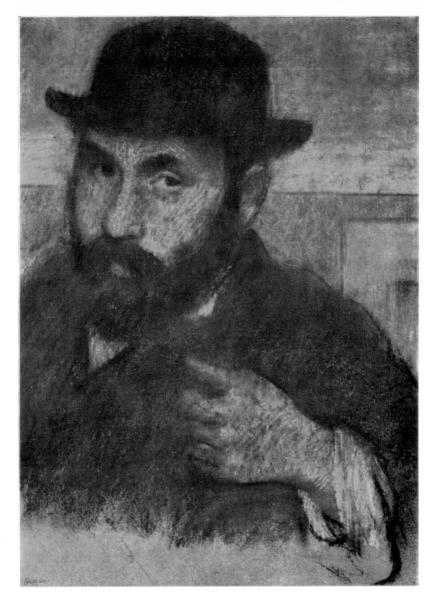

PORTRAIT OF A MAN
Pastel 1867
Former Ambroise
Vollard Collection,
Paris
E. Slomovic
Collection,
Belgrade

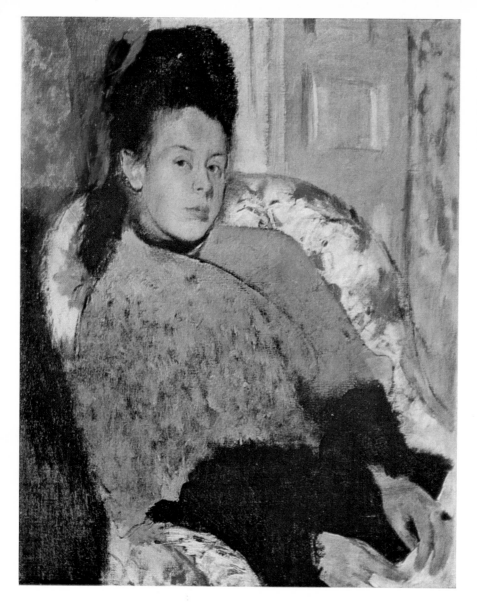

PORTRAIT OF
CAMILLE
MONTEJASI-
CICERALE
Oil 1873
National
Gallery,
London

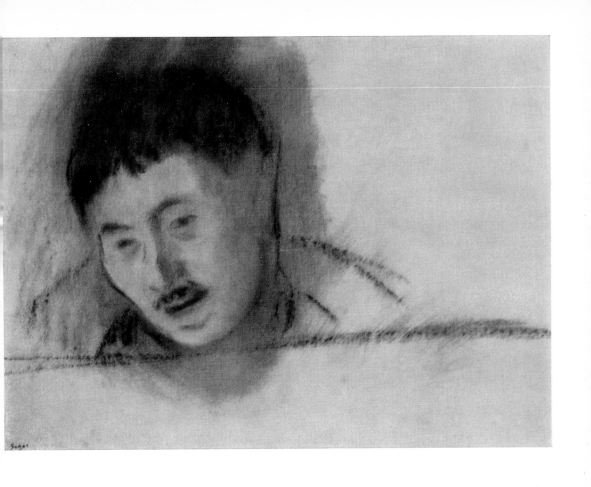

MAN'S HEAD, Oil 1881
Former Ambroise Vollard Collection, Paris
E. Slomovic Collection, Belgrade

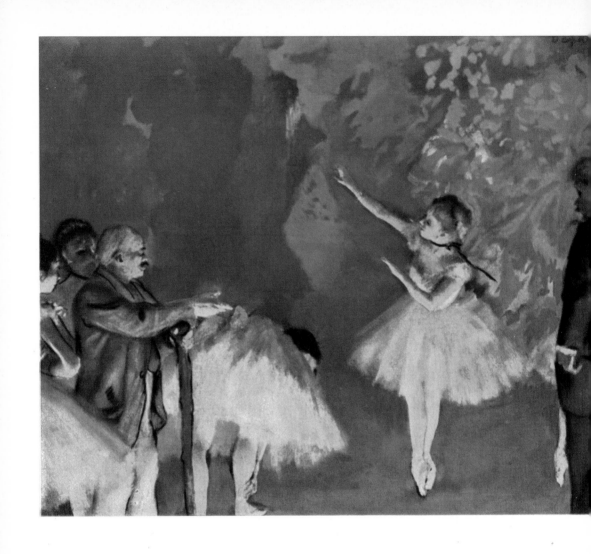

Ballet Rehearsal, Pastel 1875
G. Frelinghuysen Collection, New York

18

DANCERS
ARRANGING
THEIR DRESS
Pastel 1880
Museum of Denver,
Colorado, U.S.A.

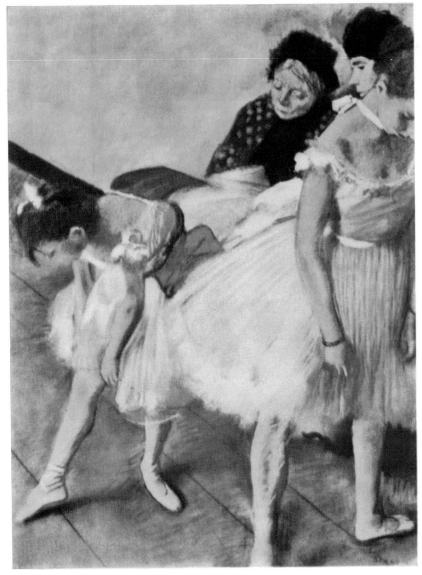

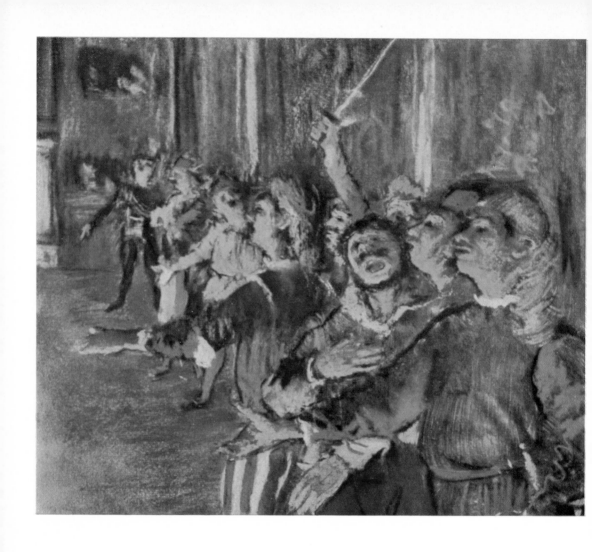

THE PLAYERS, Pastel on monotype 1877
Musée du Louvre, Paris

aloof, if not actually indifferent, to the subject he has treated. Thus it is that he begins to turn to the reality of everyday life to supply him with more topical themes. At the same time as he changes his subject, he perceives that new horizons are opening up for him; he becomes more aware of the artificiality of certain ideas that he heard praised at school and, therefore, of the danger of ending up an academic.

In this latter respect he finds himself in accord with the concern felt by his comrades, which gives rise to animated discussion when they meet at the Café Guerbois; Courbet, Manet and Zola are at the centre of this concern and of the movement to achieve freedom from preoccupation with the past, to rediscover an art that derives its inspiration from real life and rejects dead conventions; and to this end they decide to choose their models from some familiar aspect of everyday life around them. Degas, therefore, adopts these principles and is in complete agreement with the new trend.

Almost without a period of transition, he detaches himself from scholastic dogma, adheres to the same strict standard of drawing, but looks for more originality of perspective and lay-out. This state of mind has been very exactly defined by M. François Fosca, who remarks: « This determination to say 'no' to academism, this obstinate search for something new, something not yet attempted, was, for Degas, a means more than an end. He wanted to rid himself of everything that was a convention, of every banality and commonplace, in order to transcribe the truth, without anything interposing itself to distort his vision. Degas was really the first artist to carry indifference to anything that was not true to extreme lengths, the artist who is nearest to the zoologist or the psysiologist. He reproduces a human attitude in the same way as a doctor would depict a clinical case ». This definition describes all Degas' art, up to the end of his days — even when he exceeded the bounds of apparent reality to indulge in a burst of colour.

From this moment onwards, Degas had found the path that he must follow in order to satisfy his complex requirements. Moreover, the years that ensued served only to affirm and confirm his personality. This will to rebel against academism and to portray reality was to explain his participation, a few years later, in collective

exhibitions held by the Impressionists. He was then to join their ranks as a reaction against inertia and acceptance of convention, rather than as a declaration of aesthetic or technical affinity.

Indeed, we shall see that he was never tempted by the dazzling tricks of the landscape-painters, nor by the fragmented and mobile technique of painting with short strokes. On the contrary, he was to try and impart a static character to anything that was unstable, and his world of reality evades that which might seem transitory. If it was his aim to present the external truth of things, he did so with a new spirit, accepting that reality in order to interpret it from a new angle, to see it, rather, from its intimate side, to examine its characteristics from the individual, rather than the general, point of view. From that time on, he sought fresh perspectives, unexspected light-effects, audacious angles, theatrical illumination, or views painted against the light, which transformed the subject and turned a familiar scene into something new.

First of all, he was fascinated by horse-races, and it is the latter that provided most of the open-air scenes that we owe to him. Then, soon afterwards, he was drawn by a more artificial world, but one that was destined to hold him, with its strong attraction, to the very end: the theatre. Even for the least well-informed and perceptive, the name fo Degas conjures up pictures of dancers in short ballet-skirts, trying to stand on tiptoe, tying up a shoe-lace, or striking strange attitudes on the stage, depicted in astonishingly foreshortened perspective, while the footlights cast unexpected reflections on their faces.

He was to treat all these real-life themes much more fully and freely in the years that followed, but it was now that he began to explore them. Later on, it became possible to study complete series: that of the washerwomen, that of the fashion-models and, lastly, that of the nude women performing their toilet. There is a continuity in the life of Degas and in his art that was never interrupted by events and whose development was caused only by internal impulse. Even the war of 1870-1871, in which he took part as an artilleryman in Henri Rouart's battery, represents neither a break nor the approach towards another way of thinking, but merely an episode without influence, whose only effect, as far as he was concerned,

was to disperse the friends that he had been wont to meet at the Café Guerbois.

As soon as peace returned, Degas again took up the brush. In 1872, he undertook a journey to the United States of America, where he was received by two brothers of his mother, who had settled in New Orleans and become cotton-merchants. The most significant result of this journey was a curious picture, which

must be considered an important item among the works of Degas and which is at present housed at the museum in Pau. In it, we see how his own realism depicts and interprets reality — no longer according to the tenets of scholastic dogma, but with a direct vision of things; indeed, this vision is so direct that we are tempted to think that photography, which had recently been invented, was a strong influence on him, both in the spirit and in the drawing of this composition. This picture, together with another entitled « Portrait of the Belleli Family », painted about ten years earlier in Italy, is one of the canvases of that period that best give the

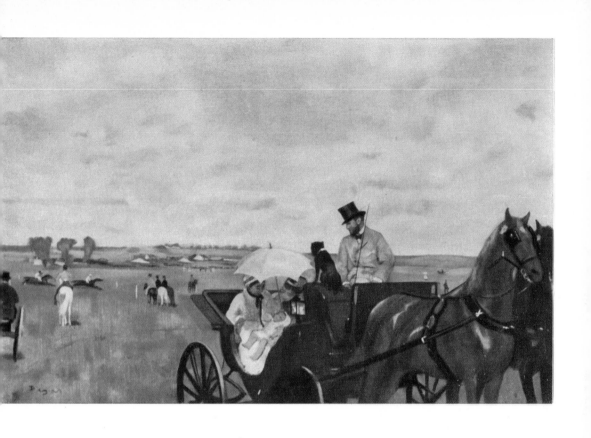

CARRIAGE AT THE RACES, Oil 1870-1873
Museum of Fine Arts, Boston, Mass., U.S.A.

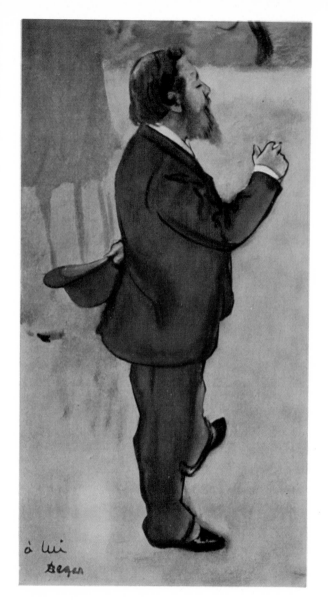

à lui
Degas

CARLO PELLEGRINI
Watercolour, pastel
and oil. 1877
Tate Gallery,
London
◁

AFTER THE BAT
Pastel 188
National Galler
Londo

26

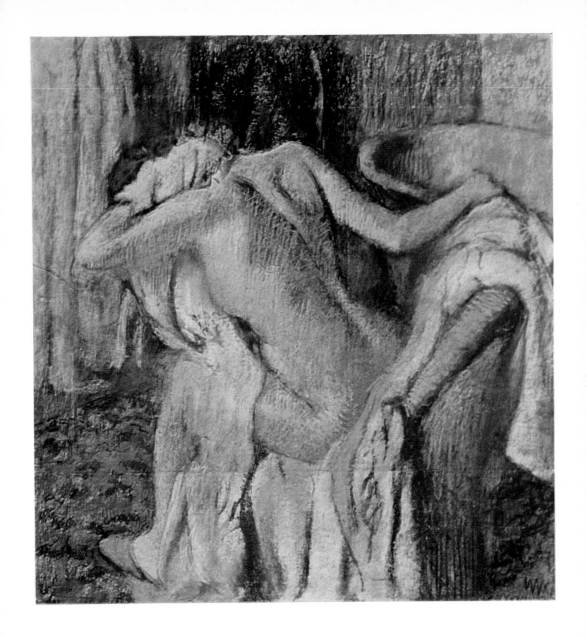

27

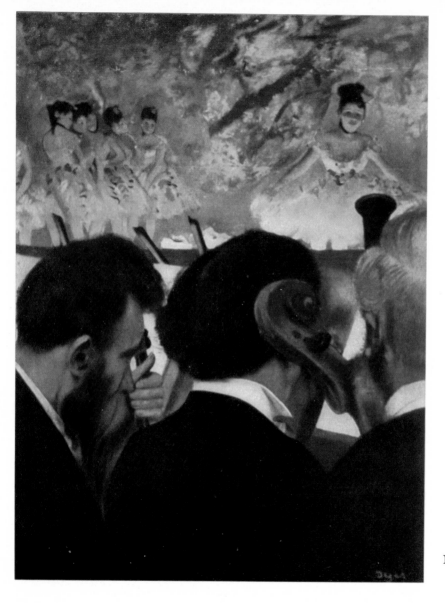

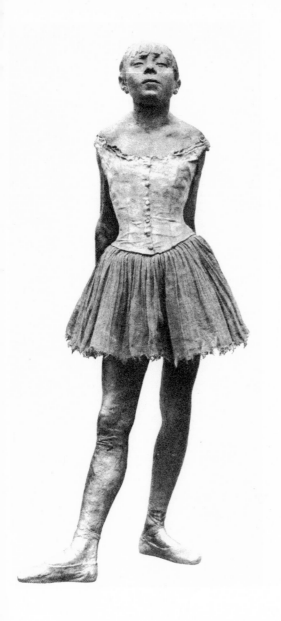
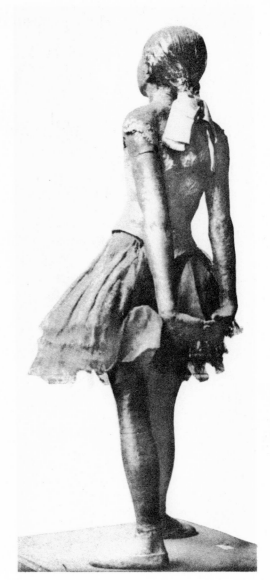

29

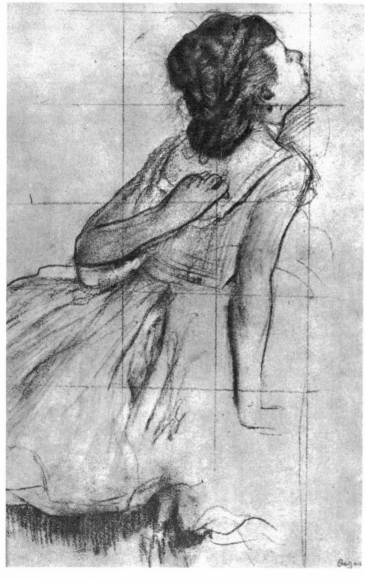

DANCER SCRATCHING
HER BACK
Pencil drawing on
grey paper,
Dr. Viand
Collection,
Paris

impression of life vividly held, of stability imposed, at that given moment.

Then, when the outburst of Impressionism came with the famous 1874 exhibition, a propitious moment had come, and the presence of Degas' work among the exhibits was perfectly justified, even though his fundamental intentions remained profoundly different, sometimes even opposed, to those of his friends. However, it is certain that Degas was one of those artists of whom it might be least expected that he would join the ranks of the Impressionists, for there was nothing in his make-up that predisposed him to engage in a revolutionary adventure, or to agree to be included in a collective movement.

True, this could also be said of Manet, but it is more true of Degas; both their works, even more than their characters, lead to this conclusion. Manet, ever since he had attended lessons by Thomas Couture, had felt that official teachings were impossible for him, and had therefore devised for himself his own way of rejecting academism; thus, it was no mere chance, nor was it without good reason, that the Impressionists created their technique by taking their lead from him and developing his ideas. Degas, for his part, issued no critical statements regarding the instruction that he had received; on the contrary, all his life he remained faithful to his admiration for Ingres. His first compositions show nothing that would lead one to expect a rebellion against his masters, but display, rather, a willing submission to accepted scholastic principles. Thus, he took part in Impressionist events without, however, adopting the mode of expression of the other painters in the group. As we have said, he did not indulge in the technique of separating tones by means of short brush-strokes, nor did he subject himelf to the discipline of light colours; he painted neither the light nor the atmosphere, nor people in the open air. His realism, his desire to bring a fresh approach to his subjects and to be in touch with life were best satisfied by indoor scenes, and although the colours that he used were noticeably lighter than before Impressionism, he nevertheless continued to show the marks of his years of study, which had left a deep impression on him, especially in his rigid drawing technique.

One of the characteristics peculiar to Degas is thus the important place occupied in his work by human beings; this applies far more to him than to any of the

other Impressionists (except for Renoir) — so much so, in fact, that this subject constitutes practically an exclusive theme in itself. His landscapes and his interiors are no more than accessories to accompany or surround his people. Not only did he paint numerous portraits, but the subjects of his most famous series are human beings.

Was it this imperative need for the human presence that led him to such painstaking, almost obstinate, observation of woman? — And he saw her not so much as an almost abstract idea, rendered semi-divine by classical tradition, but rather as woman observed, like his other subjects, in the course of everyday life. He was not, therefore, content with conventional nudes, but sough to portray the female body in intimate attitudes: women performing their toilet and caught, as it were, unawares in their privacy, the brutality of such an intrusion being corrected by all the seductiveness that Degas was capable of bringing to bear, as regards both colour and drawing.

In this painstaking and original observation it has been asserted that one could see one of the clearest manifestations of Degas' mysoginism, because he had a direct and concise way of emphasising the weaknesses of his contemporaries. However, it is said that he enjoyed female company and that what irritated him in other people was artificiality and the lack of simplicity and sincerity. It would seem that he did not try to express these sentiments in his work, which makes him appear much less aggressive than was, for example, Toulouse-Lautrec, who, according to the evidence at our disposal, was subject to his influence, albeit with more of the caricature in the majority of his portraits. The most one can say is that Degas did not try to idealize his models by artificial means, and was thus able to avoid academic convention. To show woman in her true and living state is not necessarily a proof of ill-will. It is even possible to contend the opposite, and to say that in revealing woman in her less favourable attitudes Degas shows himself to be attentive and sensitive to what is moving and somewhat animal in her, without, however, losing that grace that she shows at those moments when she is not deliberately controlling herself. Women performing their toilet, dancers resting, fashion-models, and even washerwomen, sometimes have a certain vulgarity; but Degas does

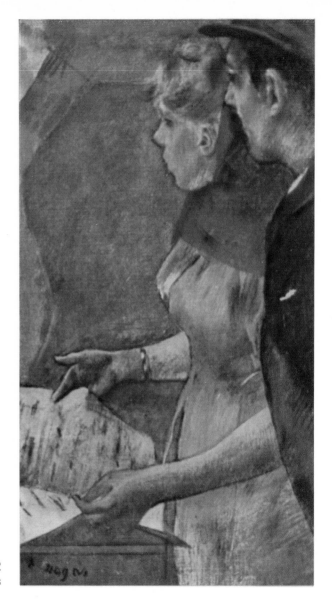

BEHIND THE SCENES Pastel 1882
Private Collection, Paris

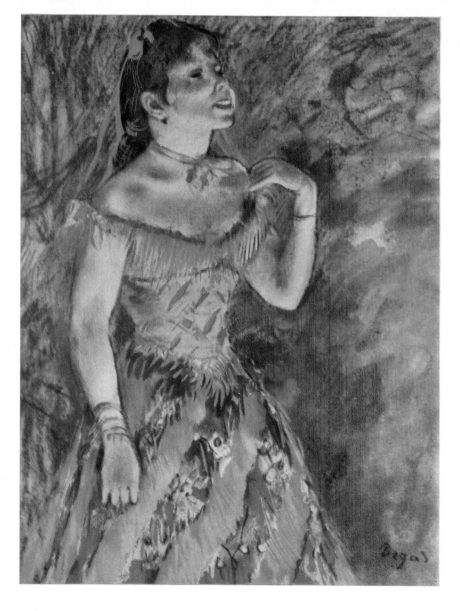

SINGER IN GREEN
Pastel 1884
Stephen Clark
Collection,
New York

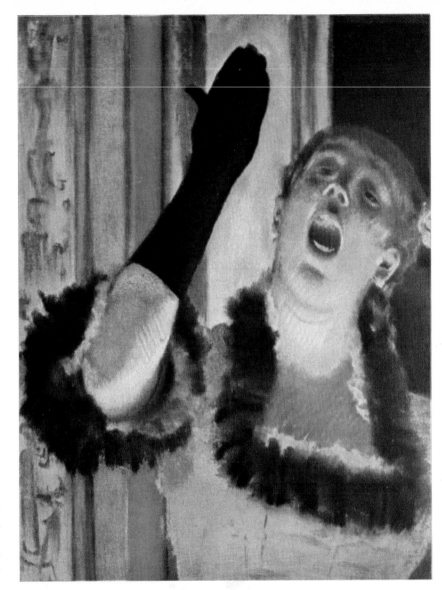

SINGER WITH
GLOVE
Pastel 1878
Maurice Wertheim
Collection,
Fogg Art Museum,
Cambridge,
Mass., U.S.A.

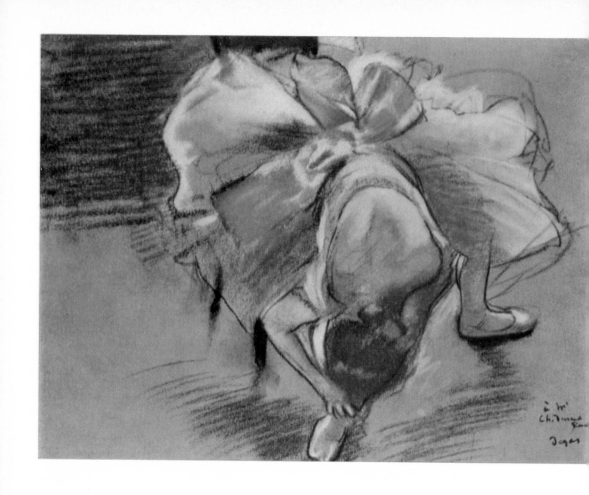

SEATED DANCER TYING HER SHOE, Pastel 1886
Durand-Ruel Collection, Paris

not distort this, and the external vulgarity is not allowed to destroy the elegance and the arabesque in the movement. It seems that, as depicted by him, human attitudes, taken by surprise and completely unaffected, are retained in order to emphasize the instinctive harmony of bodies in motion.

Apart from the particularism of the subjects chosen, special mention should be made of the importance of light in Degas' works and of the original effects that he achieves by this means. Light is a prime factor in the birth of Impressionism, but its use by Degas is peculiar to him. While his comrades made a special study

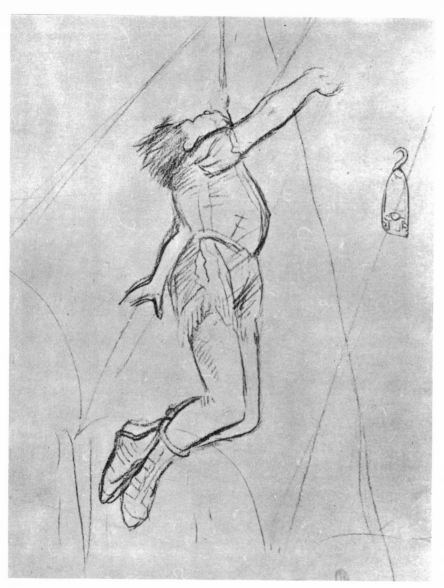

MISS LALA AT
FERNANDO'S
CIRCUS
Lud. Halévy
Collection,
Paris

of daylight, he, as his art developed, nearly always chose artificial light, particularly stage lighting, which, with the brutal brilliance of the « floats », transforms contrasts and often inverts the position of shadows on the face. In this, again, his notion of reality is totally different from that of his friends and is explained by his need to find everywhere the presence of man rather than that of nature.

The anomaly of this artificial lighting satisfies Degas' wish to compose each picture really and truly, rather than be a prey to the wiles of chance, and explains his lack for enthusiasm for open-air scenes. All his works are dominated and organised by a perfectly clear will and obey a preconceived scheme. His portraits are nearly always painted against the background of an interior, thus leaving no appearance of improvisation. Landscape interests him only when he uses it as background decoration for a portrait or a horse-race. On such occasions, it is nothing more than an accessory to which, unlike the other Impressionists, he imparts no transitory quality, but which, on the contrary, becomes a static element, just as the attitudes of his people are static. The art of Degas is characterized by a will to permanence, even permanence in movement.

The fascination exerted by artificial lighting on Degas was to cause him to revise traditional principles concerning colour with the object of finding harmonies sufficiently deep to convey the sharpness and intensity of the contrasts. Instead of attaining this object through the scintillating technique of the Impressionists, however, he preferred to use broad areas of the same tonality, animated by the vibratory effect imparted by the parallel and visible juxtaposition of a brush-stroke or a pastel line, thus achieving grained surfaces that resembled real life.

This technique allowed Degas to exploit the magical power of colour, and its radiant effect without, however, departing from the profound interest that he retained in drawing. Perhaps it was even the attraction that drawing held for him that caused him to investigate the potentialities of pastel, for the latter, to a certain extent, has closer affinities to drawing than has oil-painting. Thus, in this field, he was a great innovator, reviving the use of a process that had scarcely attracted the attention of great artists since the 18th century; but instead of that graduated intensity of colour used by the great pastel artists of the past, Degas

indulged in hatching with bold lines, thereby imparting a certain vigour to a medium that had hitherto been esteemed more for its natural suppleness.

It has been asserted that the audacity of his technique and the brightness of his colours were due, to a great extent, to an infirmity that must be particularly trying for a painter: Degas had very bad sight, which got progressively worse. However, to attribute excessive importance to this factor in the painter's technique is to overindulge in the pleasure of speculation and to ignore the strength of will and clear mind of a man like Degas. His choice of technique cannot have been dictated to him exclusively by external factors, and he must certainly have arrived at his method by a deliberate process of reason and intent.

Another main feature of Degas' art is the originality of his layout. We have already mentioned the unusual angles that he achieved with his plunging perspectives, and to this can be added the unexpected quality of the arrangement of his subject, which often touches the very edge of the picture, instead of occupying the centre in accordance with tradition. Furthermore, he obviously gives much importance to the foreground, forcing the background into the dim distance.

It is legitimate to discern in these very special features the influence of photography, in which Edgar Degas took an interest and which does, indeed, especially in instantaneous snapshots, offer surprises of this kind. Moreover, this was another way in which Degas could associate opposites and reconcile the provisional with the definite. The same methods were destined to be used a few decades later, just as systematically, by the cinema industry, and this has led people to say that Degas was a precursor in the field.

Above all, another factor that is just as important, if not more so, must be taken into account: this was the period in which Japanese prints were discovered, and with their discovery came the revelation of an aesthetic standard whose criteria are very different from ours, of a form of art that conveys the most subtly poetic feeling by means that are apparently spontaneous, yet are, in fact, carefully studied. Degas was certainly extremely interested in these prints, and he drew lessons from them the result of which can be seen in his works. Like the Japanese, he knew how to strike a subtle balance between empty and occupied space, thus discarding the principle of symmetry dear to the hearts of the classicists and replacing it by the subtlest of relationships between the two.

La Toilette
Pastel 1885
Havemeyer
Collection,
Metropolitan
Museum
of Art
New York

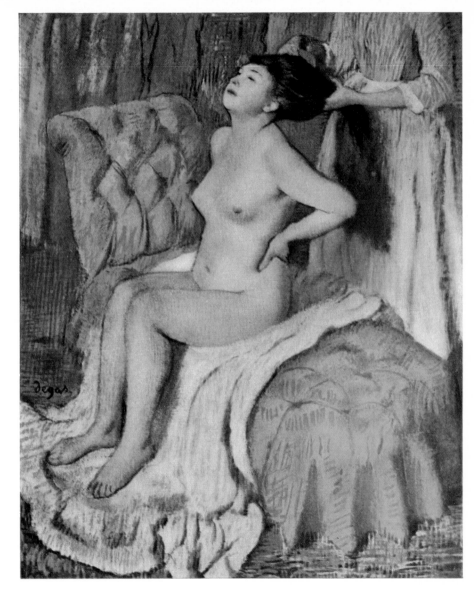

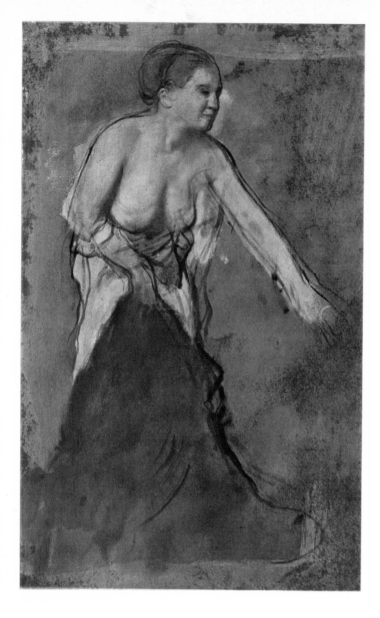

WOMAN
PERFORMING
TOILET
Oil 1887
Kunstmuseum,
Basel

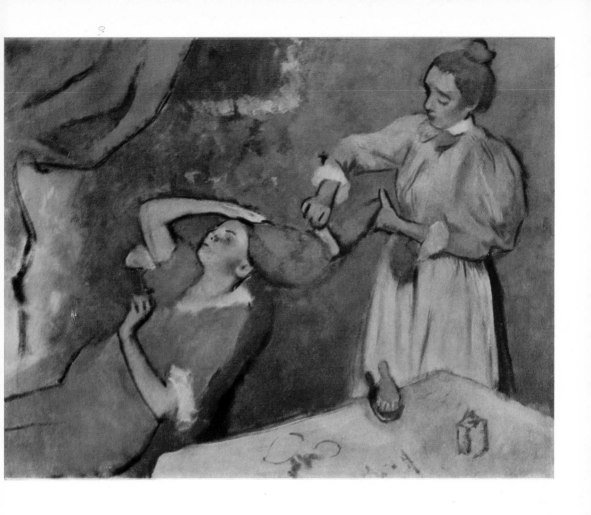

THE HAIRDRESSER, Oil 1887
National Gallery, London

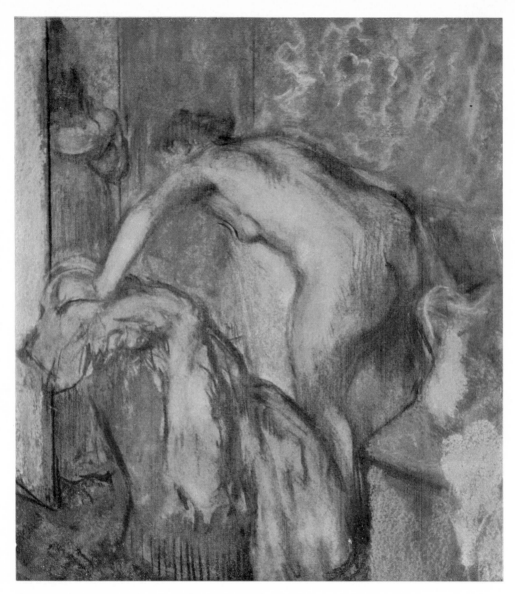

AFTER THE BATH, Pastel 1887. Durand-Ruel Collection, Paris

We may well be surprised at the reservations expressed regarding so accomplished an art that was both traditional and revolutionary. While it may, to a certain extent, be possible to understand how Degas came to be accused of misanthropy, it is difficult to agree with the motives attributed to him and to accuse him of having a taste for the ugly. His concern for the truth was not an act of hostility, but merely reflected his exacting nature, which expected even more of himself than of others. Indeed, how could he, who hated affectation and excess, ever have considered ugliness an end in itself.

This innate sense of proportion did not prevent him from taking part in Impressionist exhibitions, nor from pursuing, with the Impressionists, their fight against routine art. His constant presence among them admits of no doubt as to his feelings on this subject, and we cannot accept the opinion of commentators who would exclude Degas from the movement. He belonged to it of his own free will, although it is true that the artistic aims that he pursued were different, just as was the aesthetic ideal that he sought, and for this reason he gave the movement an open-mindedness and a breadth that were far less limited than if the standards followed had only been those of Monet and his friends.

Degas and Cézanne represent the two extremes: Cézanne, with his will of iron, looking towards the future, was the exponent of an art that was almost metallic, a rigid structure that was destined to serve as a point of departure for the audacious painters of the 20th century; while Degas, on the contrary, at the other extreme, refused to reject the past, was firmly attached to the discipline of drawing, and was therefore able, later on, to become the link, in museums, between the classical past and the new, liberal era that had just dawned. This was submission, but not coercion, and was willingly accepted because it was founded on a basic honesty and a profound culture that were able to make aggressiveness seem something sensitive and human.

The art of Degas is neither a provocation nor a concession, but an achievement that, when one takes the trouble to analyse it, exceeds all appearances. In depicting the artificial and elusive nature of the theatre, he achieves lasting expression; in painting the diaphanous vapour-like quality of ballet-dancers' skirts, he gives evidence of a sure, solid technique; and in painting portraits that one feels must be

true to life, or portraying women engaged in some task, he surpasses anecdote and becomes an exponent of his age.

Degas died during the war, in Paris, on 26 September 1917, in a place and at a time, that is, when, amid the general climate of anxiety, the death of a man, however great a painter he might have been, could do but little to add to the feeling of national crisis.

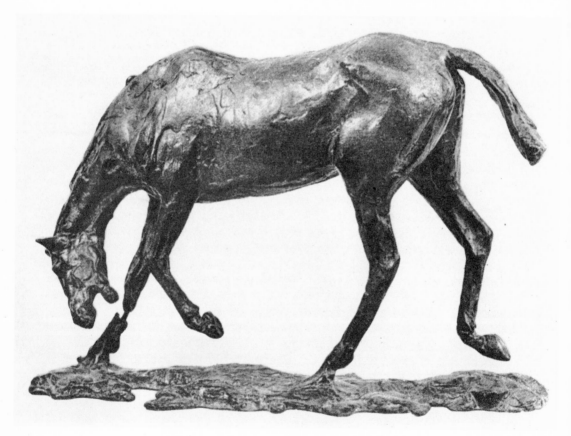

HORSE « MAKING A BOW », Bronze 1889

INDEX